Everybody Has Feelings
Todos Tenemos Sentimientos

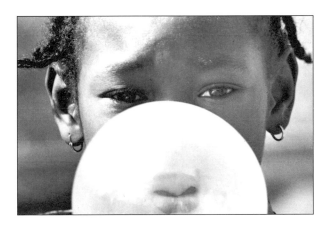

The Moods of Children
as photographed by Charles E. Avery

OPEN HAND PUBLISHING INC. • Seattle, Washington

BRIGHTON

Translation:

Sandra Marulanda

•

Book and cover design:

Deb Figen

ART & DESIGN SERVICES

OPEN HAND PUBLISHING INC.

P.O. Box 22048 • Seattle, Washington 98122 • (206)447-0597

Distributed by: **The Talman Company, Inc.**

150 Fifth Avenue • New York, NY 10011 • (212)620-3182 • (212)627-4682 FAX

Library of Congress Cataloging-in-Publication Data

Avery, Charles E., 1938-
 Everybody has feelings : a photographic essay = Todos tenemos sentimientos / by Charles E. Avery. -- 1st ed.
 p. cm.
 Summary: Photographs of children and text in both English and Spanish explore a wide range of human emotions.
 ISBN 0-940880-33-4
 1. Emotions--Juvenile literature. [1. Emotions. 2. Spanish language materials--Bilingual.] I. Title. II. Title: Todos tenemos sentimientos.
 BF561.A84 1992
 152.4'022'2--dc20
 91-40080
 CIP
 AC

FIRST EDITION Printed in the United States of America 96 95 94 93 92 7 6 5 4 3 2 1

In Spanish, the endings of many adjectives indicate gender. Where there are both male and female children in the same photo or section, the gender of the adjective corresponds to the majority of the people pictured.

En español las terminaciones de muchos adjetivos indican el género. Donde hay niños y niñas en una misma foto o sección, el género del adjetivo corresponderá a la mayoría.

Dedication

To all the brave children of the planet...

I wish you peace, health, happiness and good fortune.

•

A todos los niños valientes del planeta...

les deseo paz, salud, felicidad y dicha.

Sometimes
I feel happy

•

A veces
me siento feliz

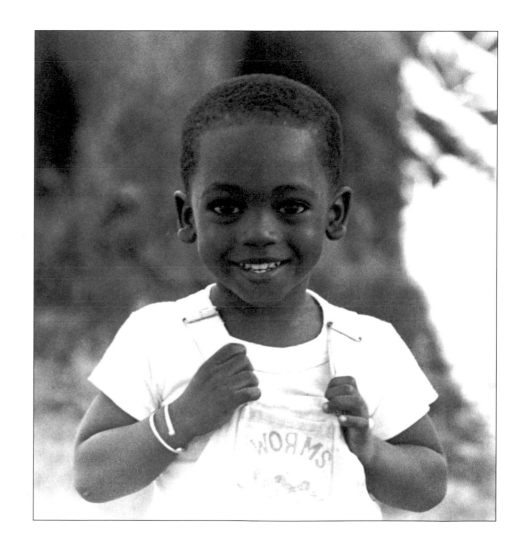

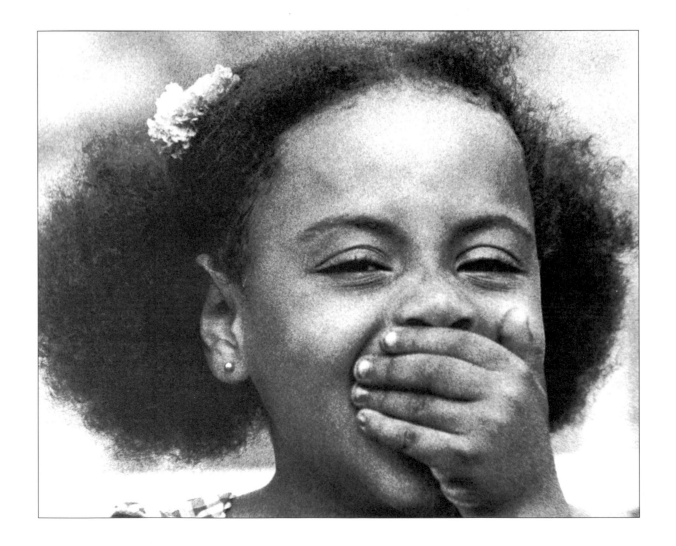

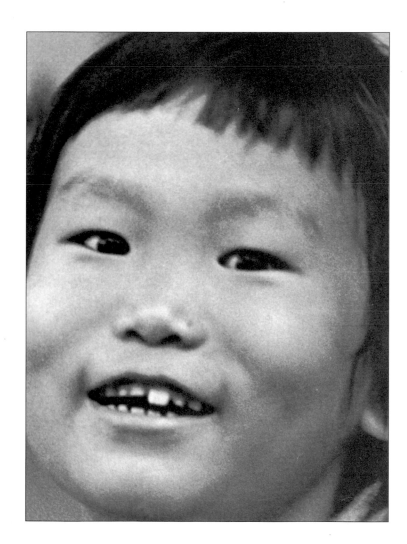

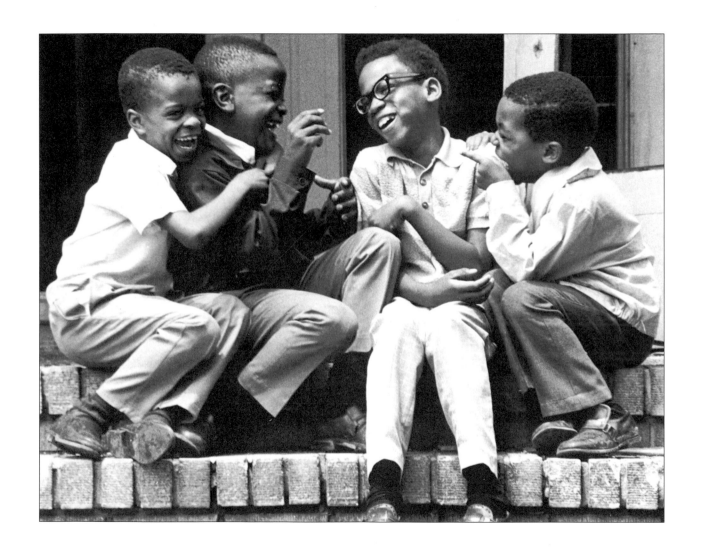

sad

•

triste

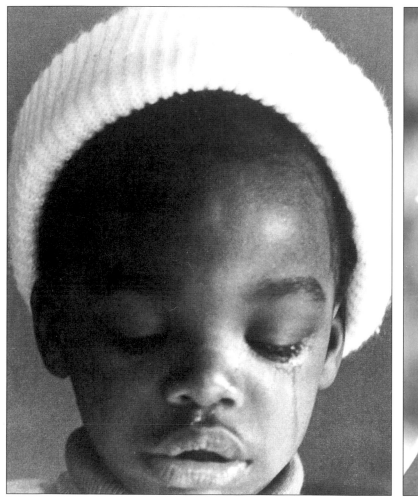
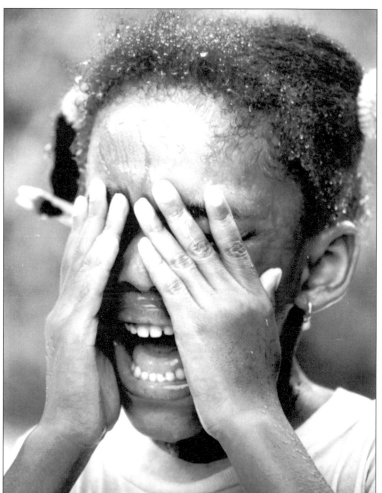

lonely

•

solo

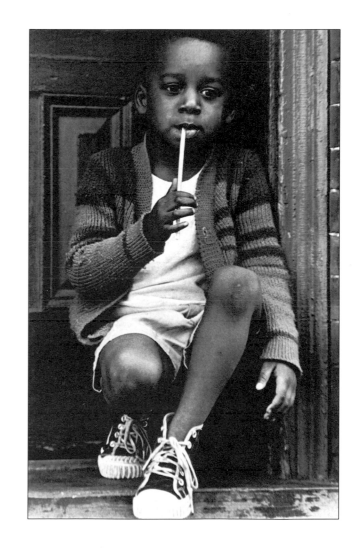

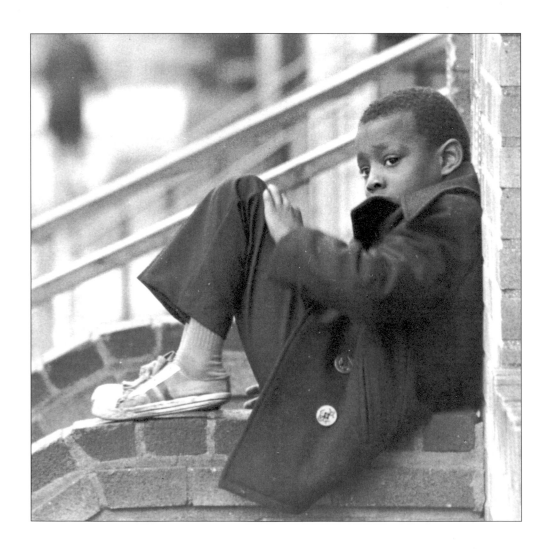

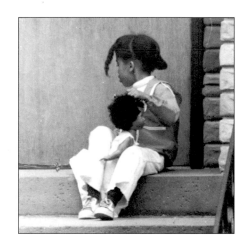

Sometimes
I like to be alone

•

A veces
me gusta estar solo

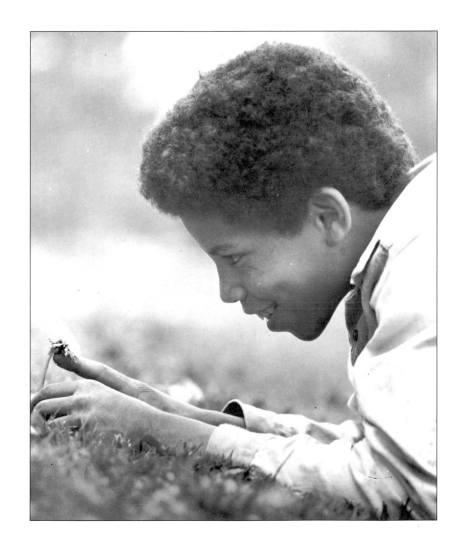

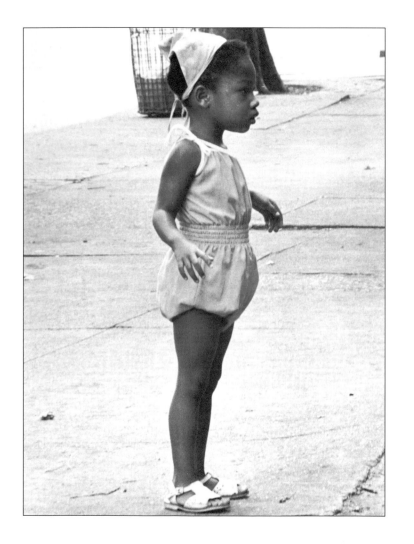
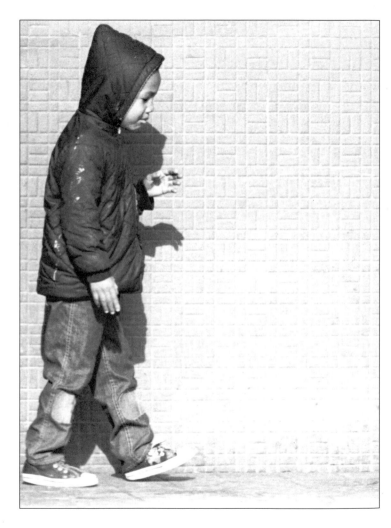

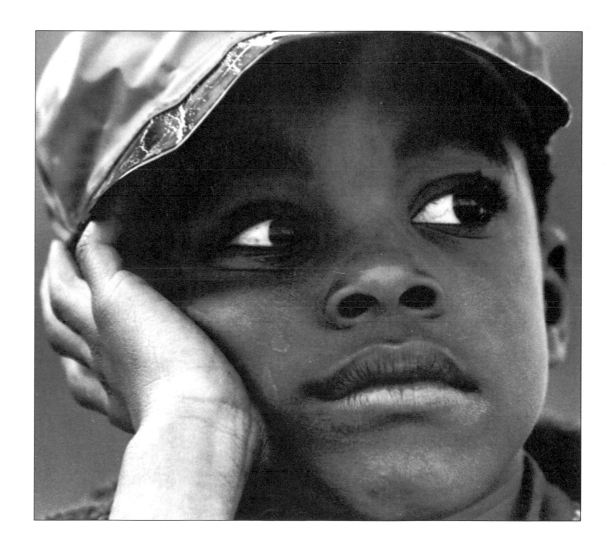

Sometimes
I feel friendly

●

A veces
me siento amigable

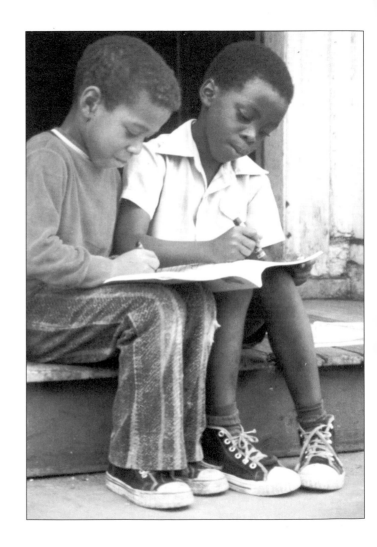

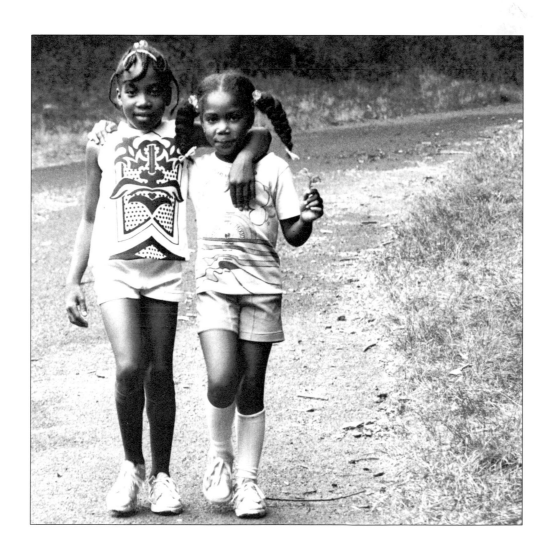

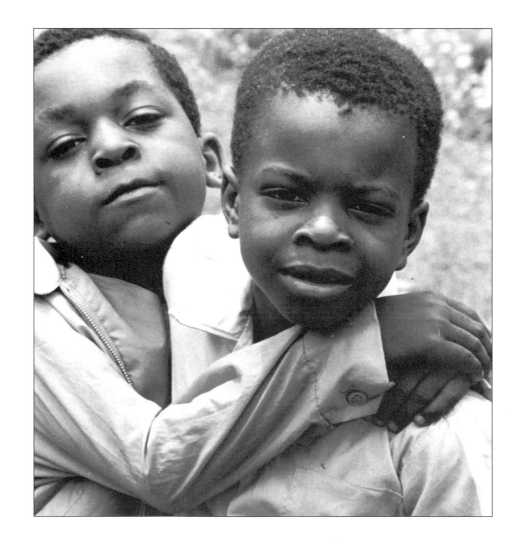

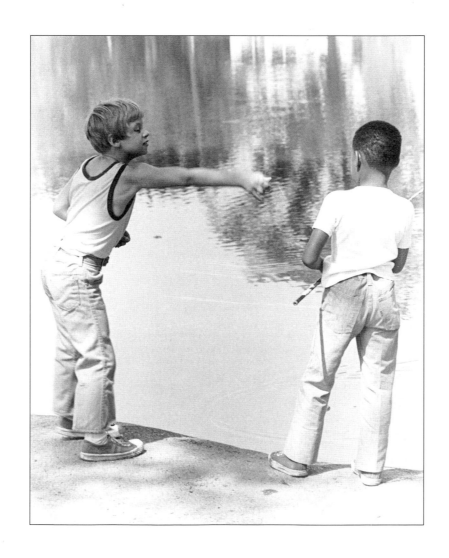

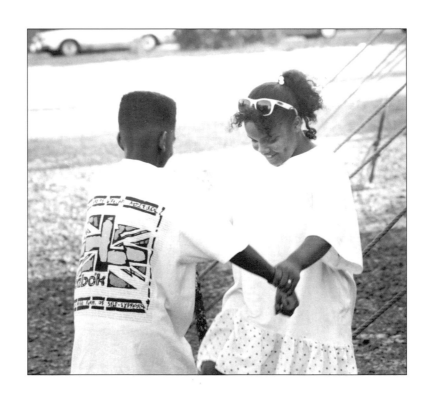

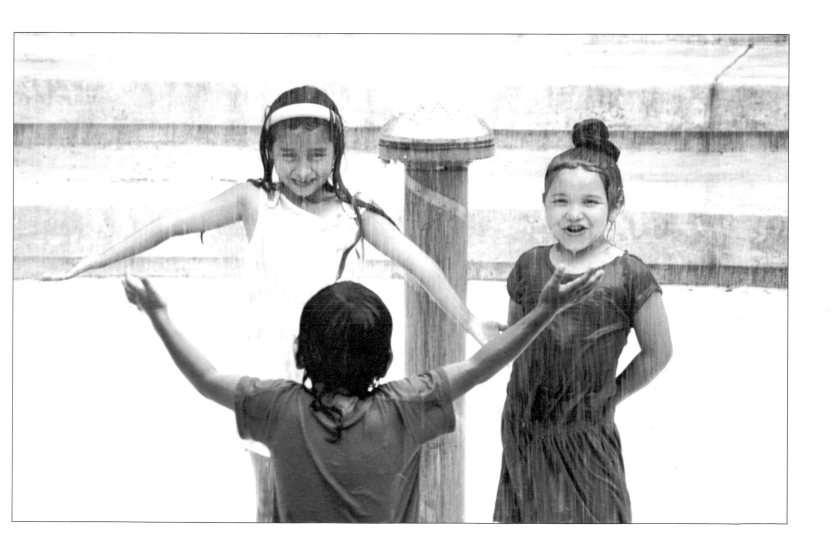

curious

•

curioso

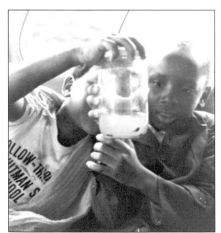

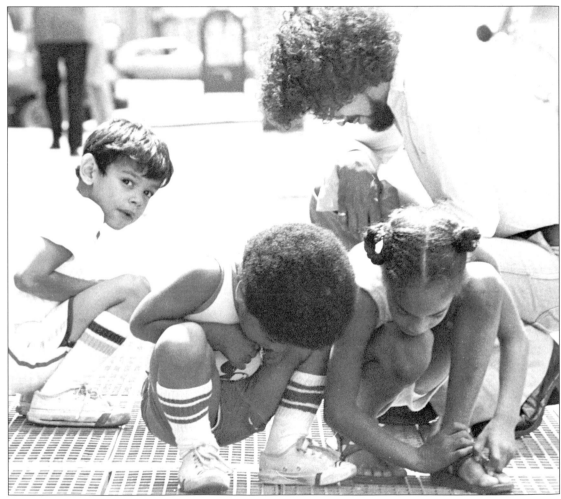

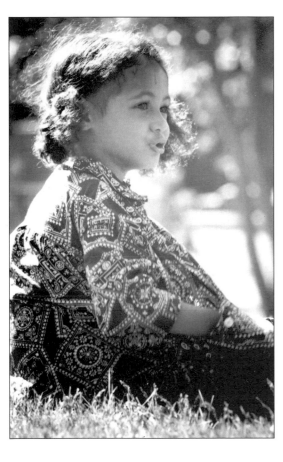

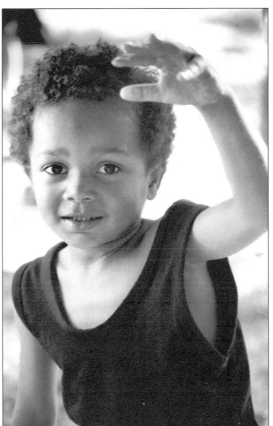

talkative

•

hablador

playful • juguetón

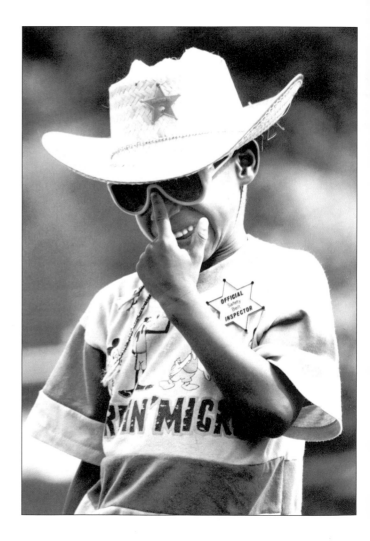

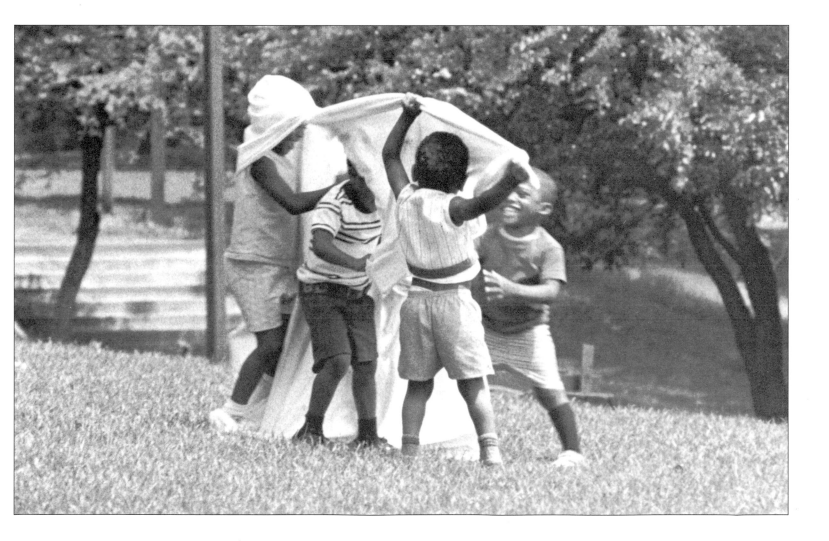

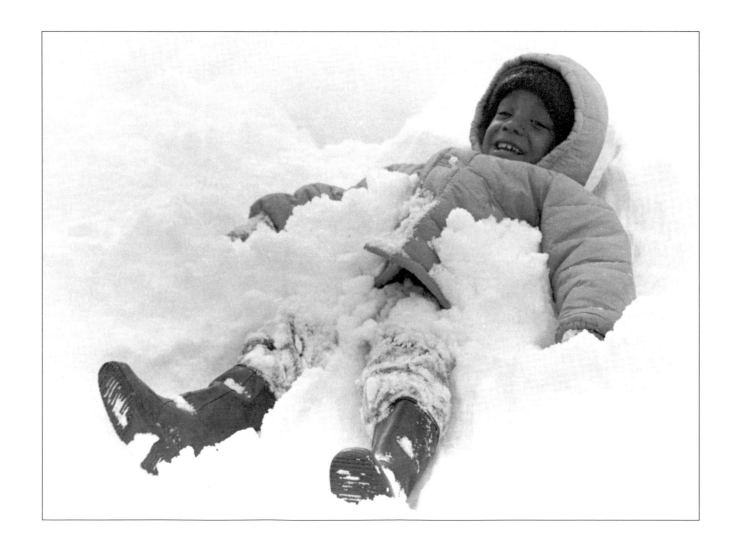

excited

•

animado

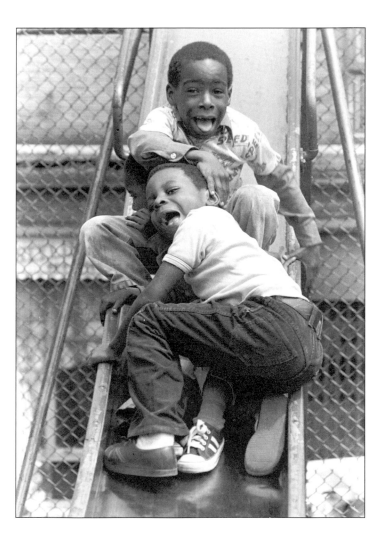

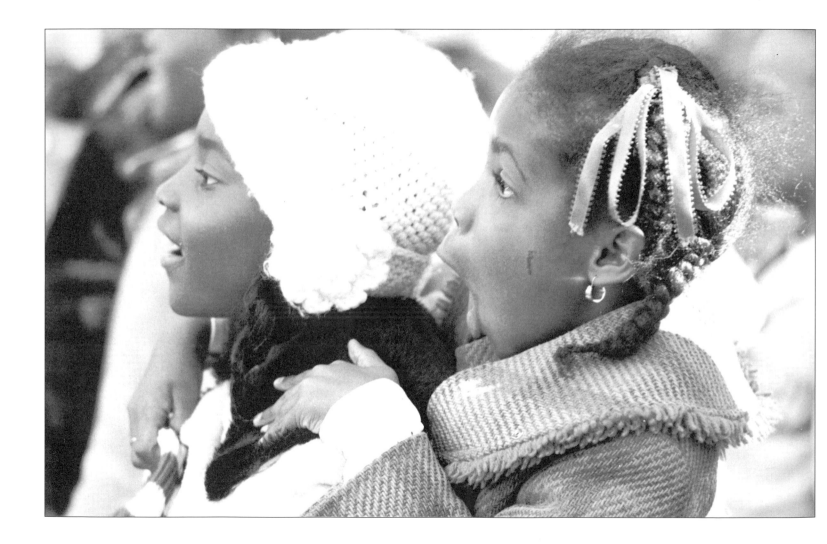

Sometimes
I feel proud

•

A veces
me siento
orgulloso

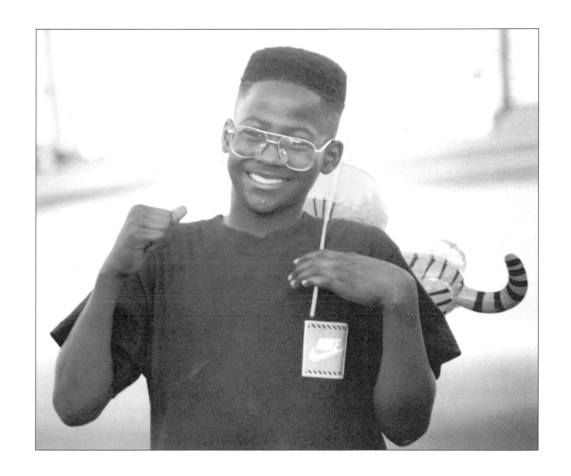

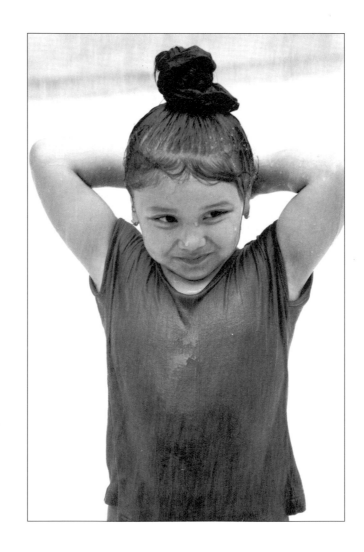

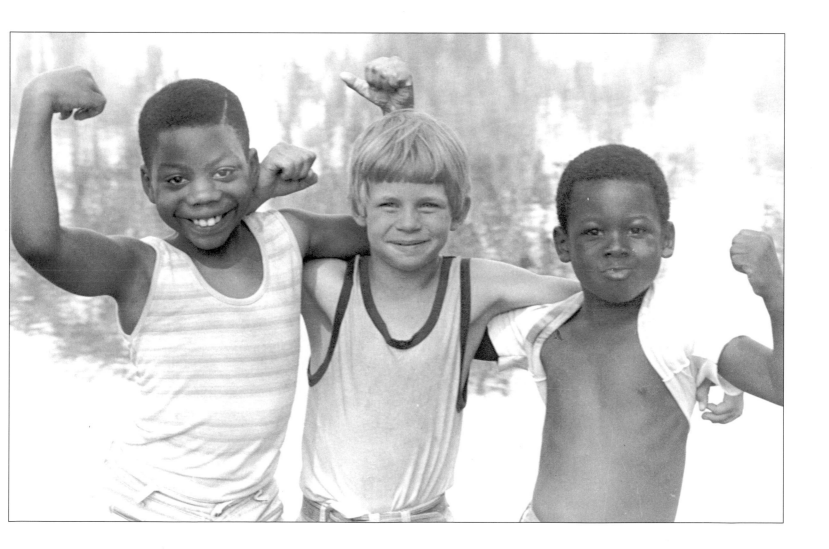

strong • fuerte

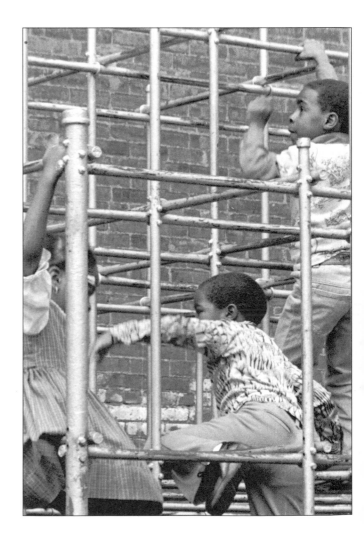

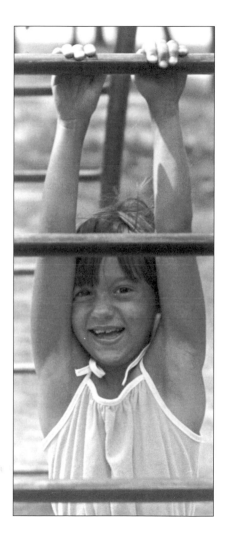

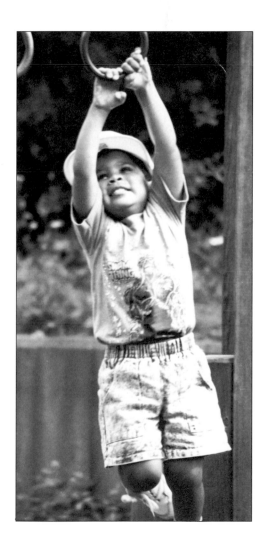

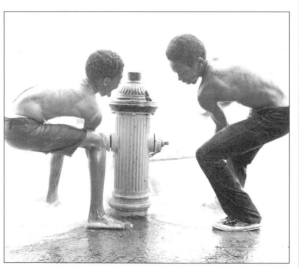

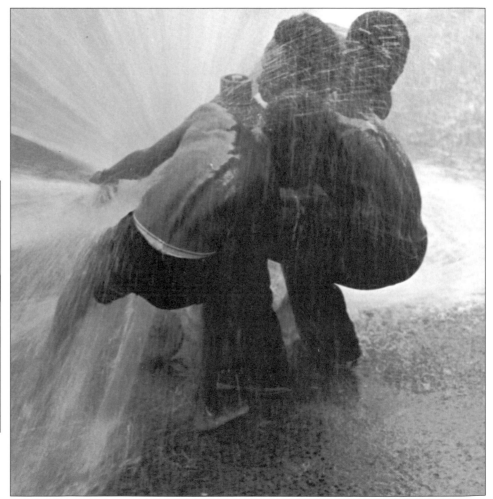

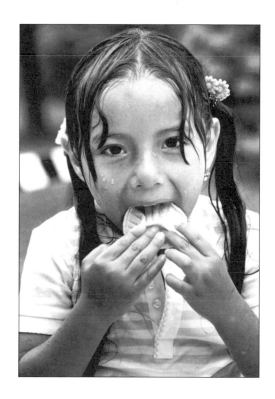

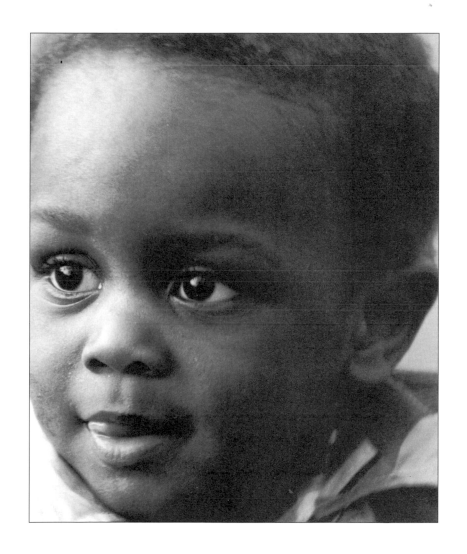

hungry • hambrienta

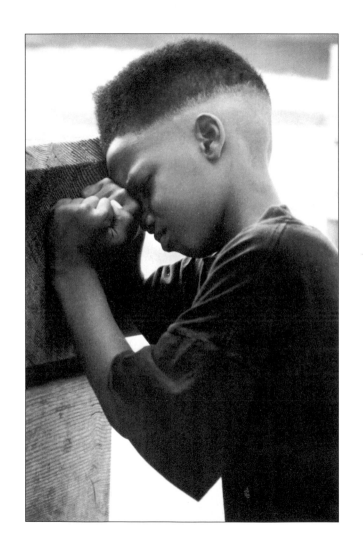

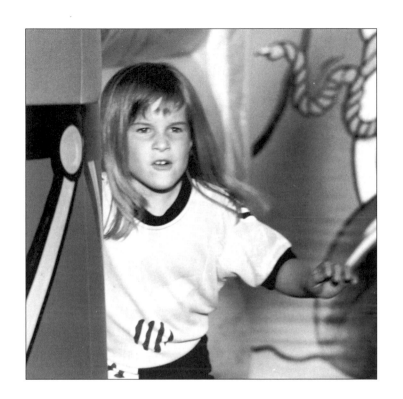

angry • furioso

Sometimes
I have mixed
feelings

•

A veces
tengo una
mezcla de
sentimientos

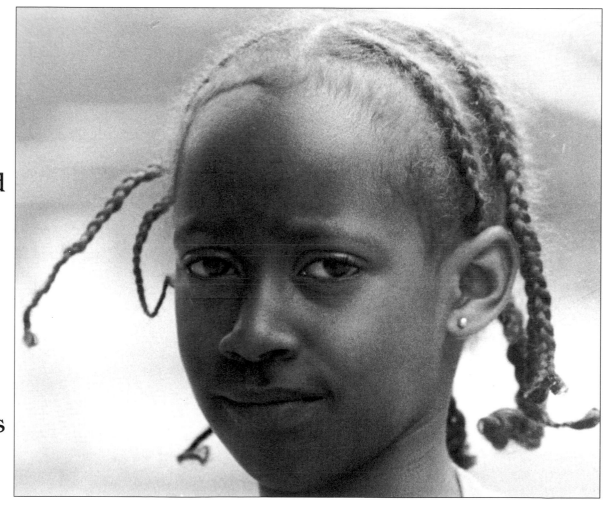

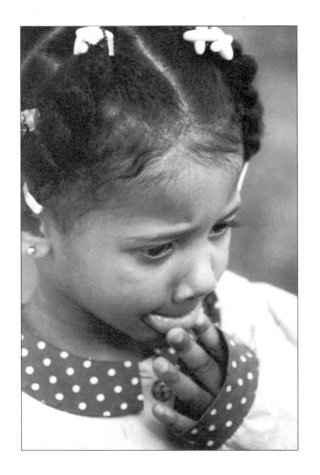 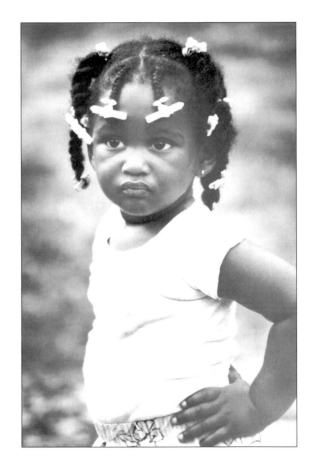

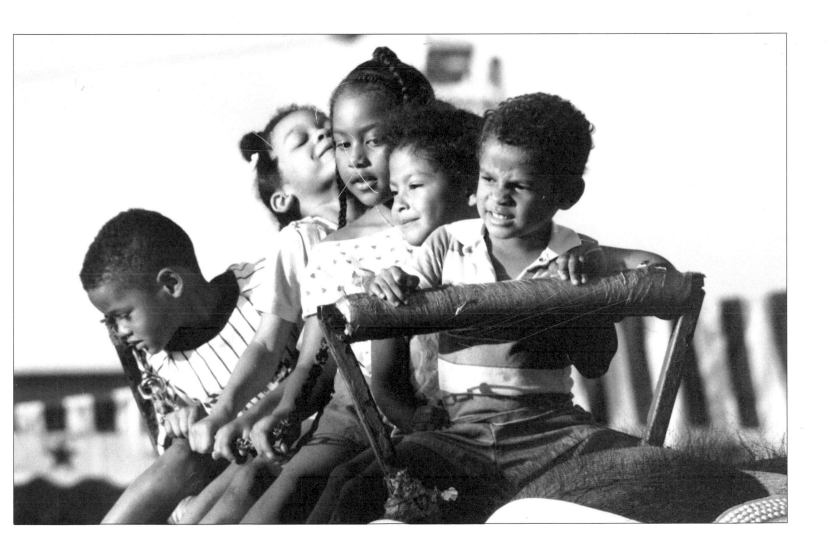

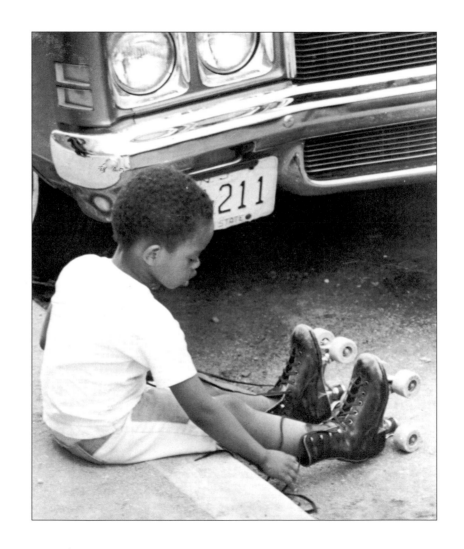

Sometimes I feel shy

•

A veces me siento tímida

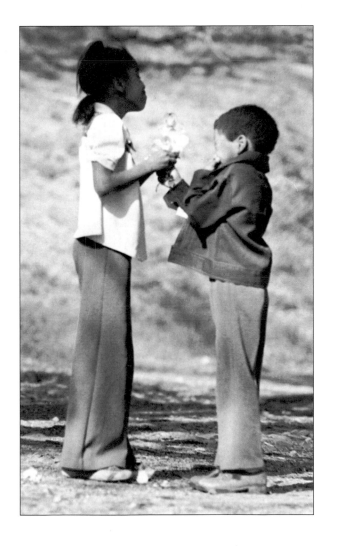

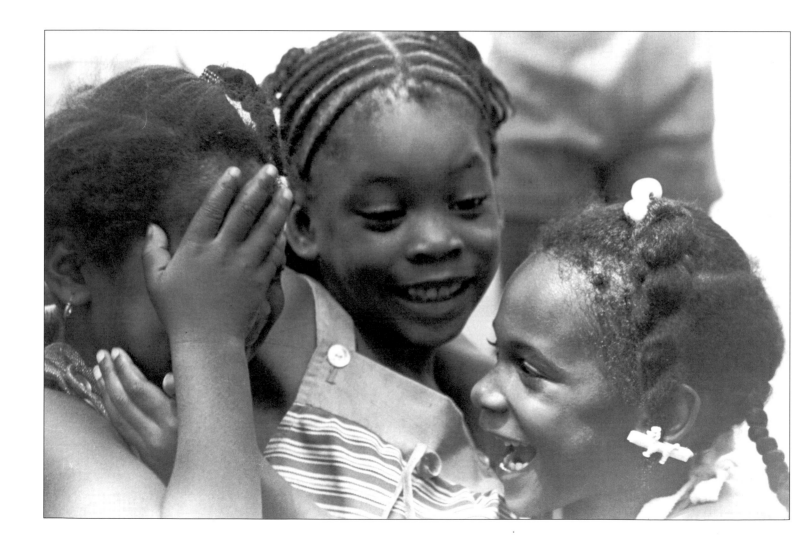

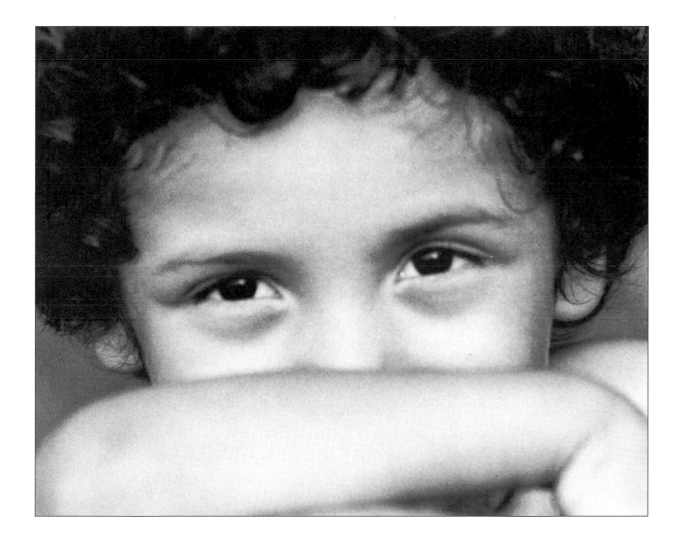

safe and trusting

•

seguro y confiado

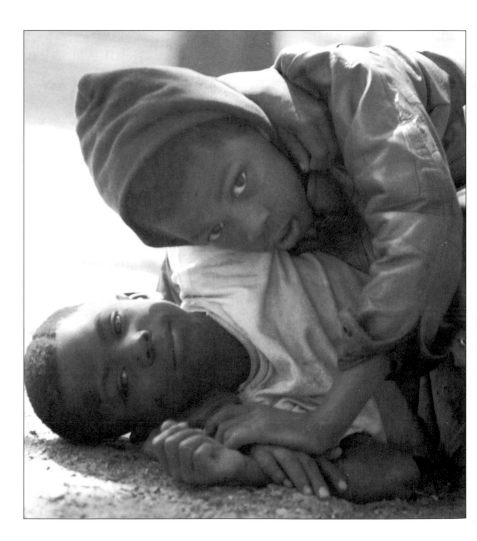

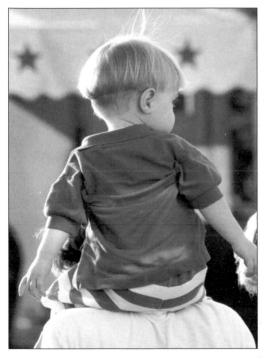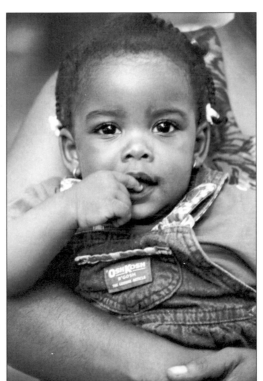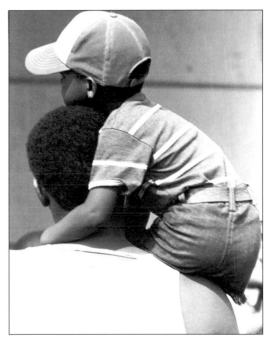

Sometimes I feel love

●

A veces me siento amada

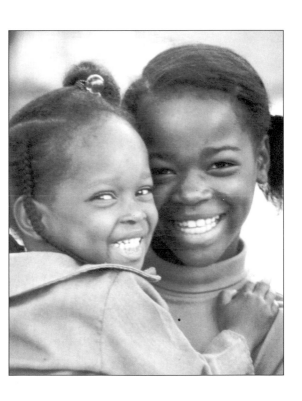

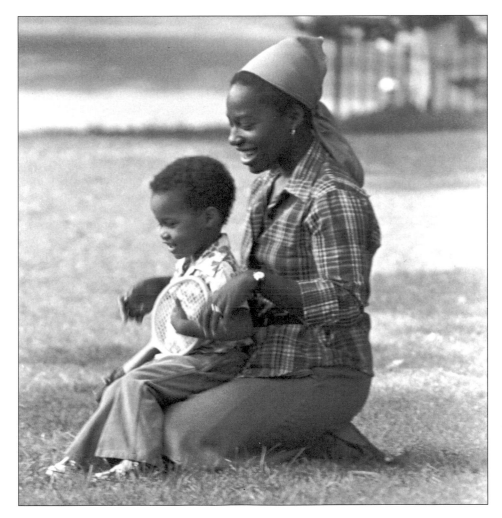